CW0066076

Aubrey Beardsley
150 Years Young

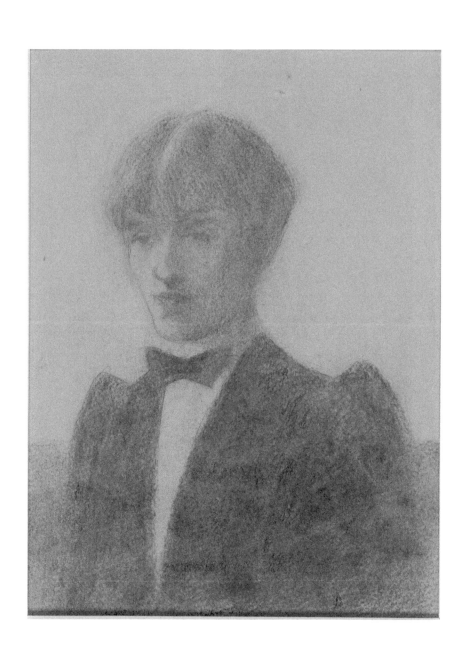

Aubrey Beardsley
150 Years Young

From the Mark Samuels Lasner Collection
University of Delaware Library, Museums and Press

MARGARET D. STETZ

New York
The Grolier Club
2022

Copyright © 2022 The Grolier Club of the City of New York

ISBN 978-1-60583-111-4

Published by

THE GROLIER CLUB
47 East 60th Street
New York, NY 10022

Printed and bound by CPI Group (UK) Ltd, Croydon, CR0 4YY

Designed by MARK SAMUELS LASNER

Catalogue of an exhibition held September 8 to November 12, 2022, at The Grolier Club

Frontispiece: AUBREY BEARDSLEY, *The Art Editor of The Yellow Book,* item [34]

Contents

Introduction

H E drew a portrait of a friend as a giant fetus in evening dress. He wrote an unfinished fantasy in which Venus masturbated her pet unicorn. He produced a theatrical poster that upstaged the plays it advertised by depicting an uncorseted woman with loose hair and her clothes slipping off. He decorated his illustrations for books and magazines with swollen penises and scattered images everywhere of hands reaching for genitalia. That was Aubrey Beardsley (1872–1898), who was born in England 150 years ago and died at the tragically early age of twenty-five. Had he lived decades longer, it is doubtful he would have gotten any older in mind or spirit. His biographer, Matthew Sturgis, quotes him as exclaiming delightedly to a London editor in 1896, "What a clever boy I am," and he remained a clever boy to the end.

Yet Beardsley was also far more than that: an artistic genius, a modern innovator in form and design, as well as a cultural radical and provocateur. Beardsley's approach could be summed up as playfulness, even outrageousness, with a purpose. His work promoted gender non-conformity in the social sphere, but also the equality of visual images with literary texts in the realms of periodical and book publishing. He reshaped notions of how to deploy black and white in prints and drawings, championed photomechanical reproduction and made art for the mass market, led the way in creating posters that dazzled the public, and turned affordable books into spectacular objects with gorgeous bindings. Although he was characterized as a British decadent, Beardsley's orientation was international, embracing influences from French and American literature, Japanese prints, German opera, and European *art nouveau*. Because of this, his effect on the arts has always been global, both during his lifetime and today.

The items on display are all drawn from the Mark Samuels Lasner Collection, which is part of the University of Delaware Library, Museums and Press in Newark, Delaware. This collection is remarkable not only for its holdings related to Beardsley—including prints, drawings, watercolors, photographs, posters, manuscripts, first editions, proofs, association and presentation copies of books, periodicals, theatre programs, and paper ephemera—but for a wealth of material

by Beardsley's contemporaries and also by his Victorian predecessors, especially the British Pre-Raphaelites. It was assembled by a long-time Grolier Club member, Mark Samuels Lasner, and reflects both his own interests and expertise and those of his partner, Margaret D. Stetz, the Mae and Robert Carter Professor of Women's Studies and Professor of Humanities at the University of Delaware. They have curated this exhibition.

As well as being a noted collector, Mark Samuels Lasner is a distinguished scholar, writer, editor, and bibliographer, who has contributed enormously to book history and art history despite being legally blind. Beardsley lived and worked with the shadow of death from tuberculosis hanging over him. Samuels Lasner has spent his life under the literal shadow of extremely low vision; yet he too has never ceased being witty, determined, and sometimes naughty.

For their invaluable assistance in creating both this catalogue and the exhibition it records—which was co-curated by Mark Samuels Lasner, and which was drawn from his collection at the University of Delaware Library, Museums and Press—enormous thanks go to all of the following people: Gretchen Adkins; Thomas G. Boss; Maev Brennan; Janet Broske; Shira Belén Buchsbaum; Amanda Domizio; Ann Donahue; Scott Ellwood; Janice Fisher; Steven Halliwell; Sheila Ann Hegy; Eric Holzenberg; Jerry Kelly; Marie Oedel; Thomas Pulhamus; Steven Rothman; Michael Ryan; Jennifer K. Sheehan; and Olivia Stone. Nothing would have been possible without them.

A Note on *The Grolier Club & Aubrey Beardsley* by Mark Samuels Lasner

Before *Aubrey Beardsley, 150 Years Young* in 2022, The Grolier Club displayed Beardsley's work on several previous occasions. The earliest was in 1894, when two cloth binding cases of his were included in an exhibition of commercial book bindings. Coming at a moment when Beardsley's name was just beginning to be known outside of Britain, this was likely his first appearance in any public venue in the U.S. Most notable in the twentieth century, however, was *Drawings and Books Illustrated by Aubrey Beardsley* in spring 1945, an exhibition that represented an important tribute at a time when Beardsley's reputation and that of Victorian art in general were in eclipse. The majority of the printed works and forty original drawings on view were lent by the organizer, Albert Eugene Gallatin (1881–1952), a Grolier member who was a collector, critic, and founder of a gallery known as "The Museum of Living Art," where he promoted avant-garde visual works. An artist himself, Gallatin, who lived in New York City, was known as the "Park Avenue Cubist." To Gallatin, Beardsley represented not the art of the past, but a startling and inspiring modernity. (In 1948, Gallatin donated his massive collection of original drawings, letters, and Beardsleyana to the Princeton University Library.) Although Gallatin's exhibition was only on display for a few weeks, it achieved a permanent afterlife when, also in 1945, The Grolier Club published his *Aubrey Beardsley: Catalogue of Drawings and Bibliography*. Long considered the standard reference work on the artist, it was joined decades later by Brian Reade's *Aubrey Beardsley* (1967), which helped to inaugurate a new "Beardsley boom" in the 1960s, and then by Mark Samuels Lasner's *A Selective Checklist of the Published Work of Aubrey Beardsley* (1995), along with Linda Gertner Zatlin's massive two-volume enterprise, *Aubrey Beardsley: A Catalogue Raisonné* (2016).

Boy Wonder

W. J. HAWKER. *Ellen Pitt Beardsley.* Photograph, albumen, [1897].

Like Jane, Lady Wilde (1821–1896), the mother of Oscar Wilde (1854–1900), who had a career in the arts (publishing poetry as "Speranza") and who nurtured her son's ambitions, Aubrey Beardsley's mother greatly influenced his future. Ellen Pitt (1846–1932) was an accomplished musician from a well-off family in Brighton and a woman with a socially defiant streak. When her ne'er-do-well husband Vincent Beardsley (1839–1909) failed to provide for her and their two children—Mabel (1871–1916) and Aubrey (1872–1898), both born in Brighton—she served as a stabilizing force, financially and emotionally. She taught Aubrey piano and encouraged his love of music and theatre, laying the groundwork for his later fascination with the world of Wagnerian opera, which resulted in his outrageously erotic novel, the unfinished *Under the Hill*, a.k.a. *Venus and Tannhäuser.* [1]

ELLEN PITT BEARDSLEY. *Aubrey Beardsley.* Autograph manuscript, 1921.

Cross-dressing appealed to Beardsley in his early years and seemed to suit him. In this reminiscence written decades after his death in 1898, Beardsley's mother described the amateur theatricals put on at home by the adolescent Aubrey and his sister, Mabel (who went on to become a teacher and eventually a professional stage performer). For *Doctor Faustus* by Christopher Marlowe (1564–1593), Beardsley was Marguerite, with "long straw plaits fastened on each side of his head." This manuscript also records memories of her son's later reluctance to fulfill his commission to illustrate an edition of *Le Morte Darthur* (1893–1894). In response to maternal prodding, he replied with a limerick: "A youth for a very small salary / Did a cartload of drawings for Malory. / When they asked him for more / He only said 'Sure / They've already enough for a gallery.'" [2]

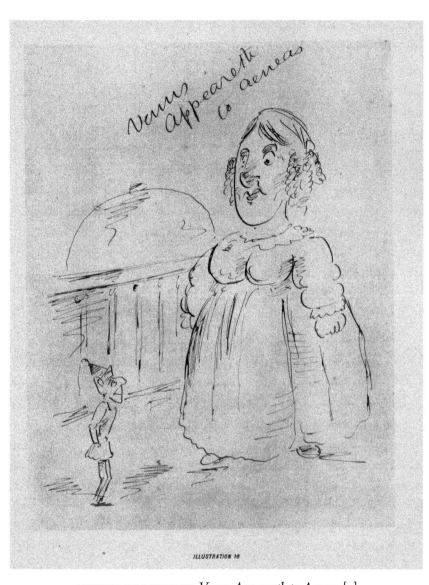

AUBREY BEARDSLEY. *Venus Appeareth to Aeneas* [3]

AUBREY BEARDSLEY. *Venus Appeareth to Aeneas,* in *Nineteen Early Drawings by Aubrey Beardsley from the Collection of Mr. Harold Hartley, with an Introduction by Georges Derry.* [London:] Privately printed, 1919.

As a student at the Brighton Grammar School, Beardsley doodled obsessively and caricatured his teachers, while creating ridiculous images to accompany whatever he was reading. Assigned Virgil's *Aeneid,* he tried translating it from the Latin, but also drew hilariously inappropriate versions of Aeneas's adventures—including this encounter with an outsized Victorian Venus—in a style reminiscent of comic works such as William Makepeace Thackeray's (1811–1863) illustrations for *The Rose and the Ring* (1855). In their 1970 edition of Beardsley's letters, Henry Maas, J. L. Duncan, and W. G. Good credit R. A. (Rainforth Armitage) Walker (1886–1960) with being "more than any other man ... the custodian of Beardsley's fame." Under the pseudonym of "Georges Derry," Walker wrote the Introduction to this 1919 edition of Beardsley's early work, from the collection of Harold Hartley (1851–1943), a British printer and publisher. [3]

AUBREY BEARDSLEY. Illustrations in "The Pay of the Pied Piper," in *The Brighton Grammar School Annual Entertainment at The Dome on Wednesday, Dec. 19, 1888: Programme & Book of Words.* Brighton: Tucknott's Steam Printing Works, 1888.

Beardsley's desire for literary fame equaled his ambitions in art. From boyhood onwards, he was writing poetry and prose. But he was attracted, too, to the world of the theatre. At age eighteen—a time when he described himself unflatteringly in a letter to A. W. King (1855–1922), his former housemaster at the Brighton Grammar School, as possessing "a vile constitution, a sallow face and sunken eyes, long red hair, a shuffling gait and a stoop"—he had a one-act comedy performed at the Brighton Pavilion. Even before this, he had appeared to acclaim in school theatricals and for one of those, an 1888 production of *The Pay of the Pied Piper* (based on "The Pied Piper of Hamelin"), he also supplied drawings that filled the accompanying booklet. At this point,

however, we see that he was more adept at depicting the chubby back-sides of rats than the bodies of human children. [4]

Questing

AUBREY BEARDSLEY. Autograph letter to G. F. Scot-son-Clark, 9 August 1891.

Beardsley admired both the art of James McNeill Whistler (1834–1903) and his dandified personal style. But whatever Beardsley thought well of, he could not resist mocking. He would later caricature Whistler as a nearly boneless figure, dwindling from a huge cloud of hair to tiny, pointed feet and seemingly in conversation with a butterfly. (Whistler's signature was a butterfly.) This early letter, however, features Beardsley's self-caricature in the famous pose of Whistler's own mother in the painting *Arrangement in Grey and Black, No. 1* (1871). The recipient, George F. Scotson-Clark (1872–1927), was a close friend from their days at the Brighton Grammar School. Here Beardsley, still under the influence of Pre-Raphaelitism, praises *The Earthly Paradise* by William Morris (1834–1896) and reports that he will again be showing his work to Edward Burne-Jones (1833–1898), whom he had approached in July 1891, seeking mentorship. [5]

AUBREY BEARDSLEY. *Design for Border for Sir Thomas Malory, Le Morte Darthur.* Ink over pencil on paper, [1892].

Having received little formal art training in his schooldays, Beardsley first taught himself to draw by copying. Even at the beginning of his professional career, which followed one year of evening classes at the Westminster School of Art, the impulse to reproduce what he saw and liked was irresistible, and what he liked were the medievalist designs of Edward Burne-Jones and William Morris—evident from this drawing of entangled leaves, vines, and flowers. The appreciation of talent was mutual in the case of Burne-Jones, who took an avuncular interest in the aspiring artist. It was decidedly not so with William Morris. When the art critic Aymer Vallance (1862–1943) brought Beardsley to meet

I herewith enclose a Real art TREASURE for you

I is a hasty impression of Whistler Miss Alexander which I saw a week or so back, a truly glorious, indescribable, mysterious & evasive picture. My impression almost amounts to an exact reproduction of Whistler's study in grey & green.

By the side of it was W's portrait of his mother, the Curtain marvellously painted, the bodies shining with wonderful silver notes. The accompanying sketch is a vile libel

By the way have you seen Whistler's letter to the paper about that picture of his at Dowdeswell's? (somewhat amusing)

A

The lights are shining dimly round about,
The Path is dark, I cannot see ahead;
and so I go on perplexed with doubt,
Nor guessing where my footsteps may be led.

B

The wind is high, the rain falls heavily
The strongest heart might well admit a fear,
For there are wrecks on land as well as sea
E'en though the haven may be very near

C

This night is dark & strength seems failing fast
Though on my journey I but late set out,
And who can tell where the way leadeth last,
Would that the lights shone clearer round about.

Farewell

Je suis pour toujours votre ami

AUBREY BEARDSLEY. Autograph letter to G. F. Scotson-Clark [5]

Book ij. Chapter j.

OF A DAMOSEL WHICH CAME GIRT WITH
A SWORD FOR TO FIND A MAN OF SUCH
VIRTUE TO DRAW IT OUT OF THE SCABBARD.

AFTER the death of Uther Pen-
dragon reigned Arthur his son,
the which had great war in his
days for to get all England into
his hand. For there were many
kings within the realm of Eng-
land, and in Wales, Scotland,
and Cornwall. So it befell on
a time, when King Arthur was
at London, there came a knight
and told the king tidings how
that the King Rience of North
Wales had reared a great
number of people, and were
entered into the land and burnt and slew the king's true
liege people. If this be true, said Arthur, it were great
shame unto mine estate, but that he were mightily withstood.
It is truth, said the knight, for I saw the host myself. Well,
said the king, let make a cry, that all the lords, knights, and

Prospectus for Sir Thomas Malory, Le Morte Darthur [7]

him, and Beardsley displayed a portfolio of his work, Morris was unimpressed and let his guests know it. [6]

Prospectus for Sir Thomas Malory, The Birth, Life, & Acts of King Arthur, of His Noble Knights of the Round Table, Their Marvellous Enquests and Adventures, the Achieving of the San Greal, and in the End, Le Morte Darthur... [London: J. M. Dent, 1893].

When the firm of J. M. Dent commissioned Beardsley to illustrate this deluxe edition of a classic of medievalism, little did it know what it was in for, although the prospectus offered hints. Throughout this lengthy project, Beardsley's style and interests were evolving. What began with tributes to Burne-Jones's work for Morris's Kelmscott Press moved in unexpected directions. Instead of just Arthurian knights of the Middle Ages, images inspired by classical mythology kept creeping in, and irrelevant naked figures invaded the designs. The influence, too, of recent encounters with Japanese prints soon was visible. Beardsley grew bored with having to churn out literally hundreds of drawings to fulfill his contract and increasingly indulged his changing tastes, as he turned from Pre-Raphaelite-ish aestheticism to decadence. [7]

SIR THOMAS MALORY. *The Birth, Life, and Acts of King Arthur, of His Noble Knights of the Round Table, Their Marvellous Enquests and Adventures, the Achieving of the San Greal, and in the End, Le Morte Darthur...* Embellished with Many Original Designs by Aubrey Beardsley. London: J. M. Dent, 1893–1894. Special issue bound in vellum. Frederick H. Evans's copy with two original Beardsley drawings and Evans's photograph of the original design for the wrapper of the parts issue.

The story of King Arthur and his knights, as written by Sir Thomas Malory (ca. 1405–1471), involved visionary aims and daring quests that ended tragically. Beardsley's massive project of designing and illustrating this edition of Malory's narrative could have gone the same way. The

tuberculosis that afflicted him from childhood onwards produced severe illness and lung hemorrhages, even as he was fulfilling J. M. Dent's commission. But he persevered, and the substantial sum he received from the publisher allowed him to quit his hated day job as a clerk in a London insurance company. (To say he was unsuited to such work would be an understatement.) He owed his liberation in part to the bookseller and photographer Frederick H. Evans (1853–1943), who had brought Beardsley to the attention of J. M. (Joseph Malaby) Dent (1849–1926). This copy of *Le Morte Darthur* belonged to Evans. [8]

AUBREY BEARDSLEY. *Design for Front Wrapper of the Parts Issue of Sir Thomas Malory, Le Morte Darthur.* Ink and pencil on paper, touched with Chinese white, [1892].

While Beardsley was turning out one drawing after another to accompany Malory's Arthurian chronicles, he was, despite his poor health, simultaneously taking on other paid visual work. The effects of exhaustion, inattention, and inexperience—at the time, Beardsley was still a youth of twenty—showed in this drawing. Not only did he misspell the title of the volume as *La Mort Darthure*, but the sloppy lettering that he produced in haste required obvious touching up. This sort of correction was possible, thanks to the new processes of photomechanical reproduction, which Beardsley embraced ardently. He became not merely an advocate for them, but their apostle. Modernity demanded speed, volume, and the mass marketing of artistic goods, and Beardsley's gaunt, elongated visage was soon the dominant public face of modern design.

[9]

Finding a Style

CHARLES LAMB and DOUGLAS JERROLD. *Bon-Mots of Charles Lamb and Douglas Jerrold, Selected by Walter Jerrold, with Grotesques by Aubrey Beardsley.* London: J. M. Dent, 1893.

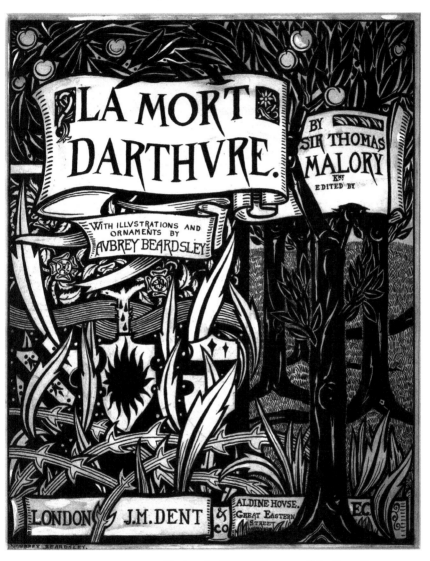

AUBREY BEARDSLEY. *Design for Front Wrapper of the Parts Issue of Sir Thomas Malory, Le Morte Darthur* [9]

SAID an individual to Jerrold one evening in a green-room—
"I believe you know a very particular friend of mine, Mrs Blank?"
Now Mrs Blank was remarkable for beauty, but it was the beauty of Venus, by no means that of Diana.

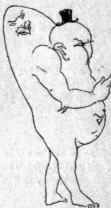

"I have met with an actress named Mrs Blank," replied Jerrold, "but she cannot be *the particular* friend you allude to."

"I beg your pardon," said his companion, "it is the same person."

"Excuse me, sir," Jerrold replied, "the lady I speak of is not very particular."

—\/\/\/—

A YOUNG author, somewhat too proud of a religious work he had written, entitled "Schism and Repentance," wished Jerrold to subscribe for a copy. Jerrold replied that he might put him down for "Schism" by all means, but he would advise him to keep "Repentance" for his publishers and readers.

Although Beardsley would soon be associated mainly with the Bodley Head firm, he continued to work for J. M. Dent on projects such as the *Bon-Mots* volumes, supplying not illustrations per se for the witty sayings of others, but images unrelated to the text. Some were merely decorative; many were savagely funny; a few, like this one, were haunting and disturbing, showing an imagination without limits, untroubled by propriety. In *Le Morte Darthur*, Beardsley had introduced suggestive nudes of vaguely classical origin. There was no precedent, however, for this aggressively gender-bending figure, with its phallic shape and pregnant belly giving birth in two directions at once, that taunted the audience and stuck out its tongue in defiance, or for the miniature top hat that it sported. [10]

SAMUEL FOOTE and THEODORE HOOK. *Bon-Mots of Samuel Foote and Theodore Hook, Selected by Walter Jerrold, with Grotesques by Aubrey Beardsley.* London: J. M. Dent, 1894.

It was meant as a joke when, in the essay "Diminuendo" from *The Works of Max Beerbohm* (1896), the twenty-four-year-old Beerbohm bemoaned his outmodedness by announcing wearily, "I belong to the Beardsley period." Ironically, many subsequent commentators have indeed viewed the 1890s as defined by Beardsley's art. Max Beerbohm (1872–1956) and Beardsley were exact contemporaries with much in common. They were brilliant artists and visual wits who also wished to be famous for their writing, though Beerbohm had gone to Oxford, while Beardsley went straight from grammar school to clerking in an office. Beerbohm, too, was the more dedicated dandy, known for his impeccable dress. In this caricature for a Bon-Mots volume, Beardsley drew Beerbohm, whom he first met in 1894, in evening clothes, but with a head that resembled both a fetus—a recurring presence in Beardsley's work—and a grotesquely large penis with a face. [11]

AUBREY BEARDSLEY. *Design for Title-page of Frances Burney, Evelina.* Ink on paper, [1892].

Restraint, sobriety, and attention to period style were not qualities usually associated with Beardsley, but they were in his repertoire. Although

he reveled in the unfettered exercise of imagination, he could be an excellent mimic when writing prose and an accurate copyist when drawing. His design for the title-page of a new edition of *Evelina* (1778) by Frances ("Fanny") Burney (1752–1840), which included illustrations by a Victorian contemporary, W. Cubitt Cooke (1866–1951), showed careful study of how eighteenth-century volumes looked. Yet Beardsley still inserted touches in line with his own preoccupations, such as the bare-breasted figures flanking each side of the columns near the top, along with a central animal head that seemed less a trophy than a mounted skull. Sex and death were never far from his thoughts or from the work of his pen. [12]

AUBREY BEARDSLEY. *Bookplate of John Lumsden Propert.* Photomechanical engraving, 1893.

Contemporaries who saw Beardsley as a leader of the emerging decadent movement defined decadence as a subversion of or transgression against convention through strangeness, morbidity, and ugliness. Beardsley's decadence offended, but it also puzzled. Why would a pallid, ghostly Pierrot sue for the favor of a malevolent, black-clad woman with a face like an angry cat? The artist offered no explanation of the drama enacted in this bookplate, designed for John Lumsden Propert (1834–1902), and there was no reason to think that such a design would have suited a physician who was also an expert on miniatures. In an 1897 letter to a Birmingham bookseller, Propert himself called the bookplate "peculiar"; yet Beardsley obviously thought well enough of it to reproduce it in the April 1894 number of *The Yellow Book*. [13]

At the Bodley Head

J. RUSSELL & SONS. *George Egerton.* Photograph, albumen cabinet card, [ca. 1894].

They had little direct contact, but Mary Chavelita Dunne (1859–1945), who published as "George Egerton," and Beardsley played important roles in each other's careers. When her first book was published by the

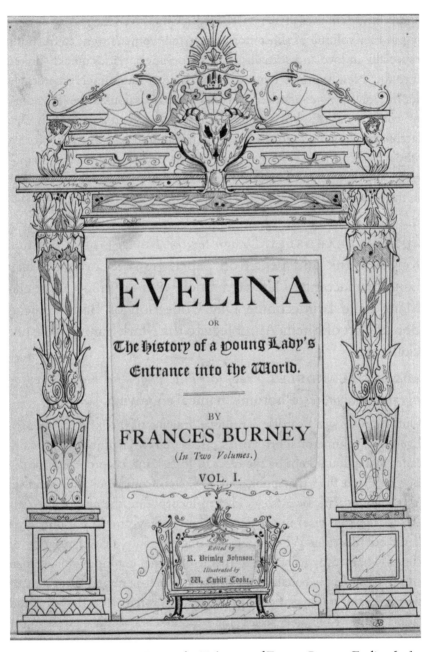

EVELINA

OR

𝔗𝔥𝔢 𝔥𝔦𝔰𝔱𝔬𝔯𝔶 𝔬𝔣 𝔞 𝔶𝔬𝔲𝔫𝔤 𝔏𝔞𝔡𝔶'𝔰
𝔈𝔫𝔱𝔯𝔞𝔫𝔠𝔢 𝔦𝔫𝔱𝔬 𝔱𝔥𝔢 𝔚𝔬𝔯𝔩𝔡.

BY

FRANCES BURNEY

(In Two Volumes.)

VOL. I.

Edited by
R. Brimley Johnson.
Illustrated by
W. Cubitt Cooke.

AUBREY BEARDSLEY. *Design for Title-page of Frances Burney,* Evelina *[12]*

Bodley Head, the firm established in 1887 by John Lane (1854–1925) and Elkin Mathews (1851–1921), Beardsley was given the task of designing it. Her volume of short stories asserted women's right to freedom, especially in love and sexuality. Not surprisingly, critics quickly linked it to the "New Women" movement, praising or damning it accordingly. Its title of *Keynotes* alluded to wildness and passion as the "keynotes" of women's natures, but also to debates over women having their own latchkeys, allowing them to leave the house unchaperoned. Beardsley, who may never have read the contents first, packaged them in a memorable way that helped to create a bestseller and increased his own fame in the process. [14]

AUBREY BEARDSLEY. *Design for the Key of George Egerton, Keynotes.* Ink and pencil on paper, [1893]. Cordelia Mary Lane Brimacombe Day, Scrapbook, 1892–ca. 1899. Cordelia Mary Lane Brimacombe Day Collection of Bodley Head Books, Gift of Sheila Ann Hegy to the Mark Samuels Lasner Collection.

AUBREY BEARDSLEY. *Proof for Title-page and Key of George Egerton, Keynotes.* Photomechanical engraving, [1893].

Only recently was Beardsley's original drawing of the "key" for "George Egerton's" volume of short stories discovered. It lay unnoticed for decades in an album kept by the niece of John Lane, co-proprietor of the Bodley Head firm that published *Keynotes*, from whom she received it as a young girl. Beardsley's idea to incorporate the author's initials ("G. E.," in this case) in the pseudo-antique key proved not only brilliant, but durable. When *Keynotes* unexpectedly sold thousands of copies—helped by its shocking theme of sexual autonomy for women and by Beardsley's equally shocking and much-parodied cover and title-page, with a female figure grabbing her crotch—the Bodley Head launched its "Keynotes Series" for connoisseurs of the newest, most daring literary fiction. Beardsley received the commission to design each successive volume, and he branded the spine and back cover with a different key, using its author's initials. [15 & 16]

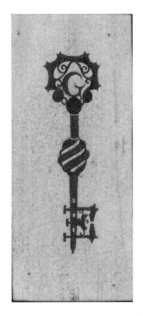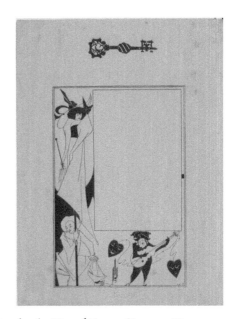

AUBREY BEARDSLEY. *Design for the Key of George Egerton, Keynotes* and *Proof for Title-page and Key* [15 & 16]

GEORGE EGERTON. *Keynotes* [18]

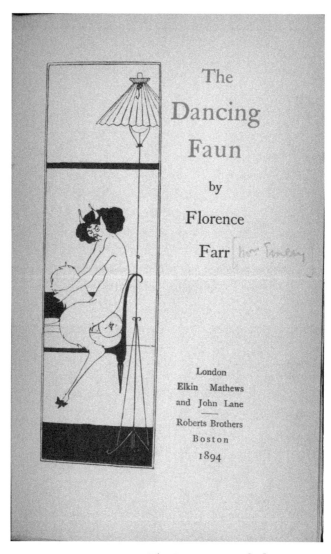

The
Dancing
Faun

by

Florence

Farr

London
Elkin Mathews
and John Lane
———
Roberts Brothers
Boston
1894

FLORENCE FARR. *The Dancing Faun* [19]

GEORGE EGERTON. *Keynotes.* London: Elkin Mathews and John Lane, 1893. First issue, in original wrappers.

GEORGE EGERTON. *Keynotes.* London: Elkin Mathews and John Lane, 1893. George Egerton's copy, inscribed to John Lane, in embroidered cloth wrapper.

Before the Bodley Head settled upon green cloth for *Keynotes* and cloth bindings for all books subsequently in the "Keynotes Series" (many of which were designed by Beardsley, before his dismissal amid the moral panic over the Wilde Trials), it experimented with paper wrappers. The front cover and title-page for *Keynotes* were identical and reflected humorously Beardsley's own preoccupations—Pierrots, phallic poles and instruments, unnaturally tiny feet, hands reaching for genitalia, etc.—more than anything Mary Chavelita Dunne, a.k.a. "George Egerton," had written. Later, she got her own back in the most literal way, presenting to John Lane a copy with a cover she had embroidered herself, overriding Beardsley's intentions. For Beardsley's masturbating-woman-on-a-stick, she substituted a floral design alluding to her Irish heritage. She kept, however, Beardsley's notion of a key with her initials woven in, decorating the back cover with her sewn interpretation of it.

[17 & 18]

FLORENCE FARR. *The Dancing Faun.* London: Elkin Mathews and John Lane, 1894. Ella D'Arcy's copy, presented to her by John Lane.

Watching his sister, Mabel, throw over her teaching position and forge a stage career helped to make Beardsley sympathetic to women performers' struggles. One contemporary who managed to succeed as both an actress and author was Florence Farr (1860–1917). Her novel about Society and the theatre, *The Dancing Faun,* was the second volume in the Bodley Head's "Keynotes Series." Despite Beardsley's appreciation of talented professional women, he could not resist doing to Farr what he had done to "George Egerton"—i.e., creating a cover and title-page that bore no relation to the text, but instead represented self-indulgence in depicting what amused him. That meant drawing a faun with a head that was a caricature of J. M. Whistler's, holding its leg as though grasp-

ing a huge, furry penis. This copy belonged to Ella D'Arcy (1857–1937), who wrote a "Keynotes Series" volume and was sub-editor of *The Yellow Book*. [19]

FYODOR DOSTOEVSKY. *Poor Folk: Translated from the Russian of F. Dostoievsky by Lena Milman, with an Introduction by George Moore.* London: Elkin Mathews and John Lane, 1894. Inscribed by George Moore to Arthur Symons.

FYODOR DOSTOEVSKY. *Poor Folk: Translated from the Russian of F. Dostoievsky by Lena Milman, with an Introduction by George Moore.* London: Elkin Mathews and John Lane, 1894. Unique morocco binding with Beardsley design, presented to "Violet" by Lena Milman.

There was no overstating the hostility of conservative British bookbuyers to "foreign" literature, especially French, though also Russian. Not until 1894 was *Poor Folk* (1846), the first novel by Fyodor Dostoevsky (1821–1881), translated into English. Its translator, Lena Milman (1862–1914), was an architectural historian and *Yellow Book* contributor. *Poor Folk* became the third title in the "Keynotes Series," which John Lane oversaw. (From the start of their partnership, Elkin Mathews was more interested in publishing poetry.) Once again, Beardsley created a cover and title-page that drew both commentary and visual parodies, as journalists and critics seized on the offending drainpipe. The clothbound copy here was a gift from the Irish novelist George Moore (1852–1933), author of the Introduction, to the poet Arthur Symons (1865–1945). Milman presented the other copy, beautifully bound with Beardsley's design in gold-on-leather, to "Violet" (possibly the novelist Violet Hunt, 1862–1942). [20 & 21]

Keynotes Series of Novels and Short Stories: Twenty-One Designs by Aubrey Beardsley, with Press Notices. London: John Lane, 1896.

Oscar Wilde's prosecution for "gross indecency" led to chaos at the Bodley Head, which had been publishing Wilde's work in the 1890s. During

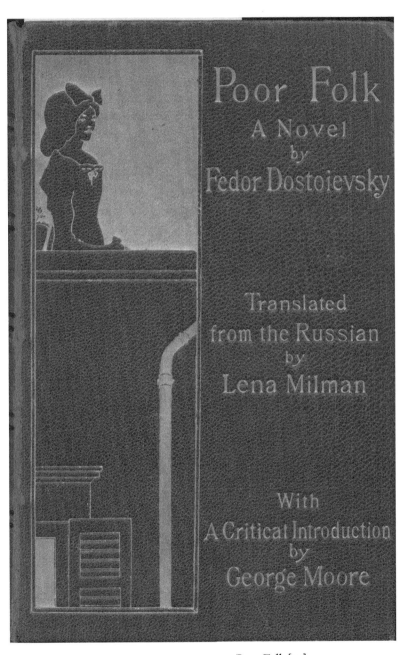

Poor Folk
A Novel
by
Fedor Dostoievsky

Translated
from the Russian
by
Lena Milman

With
A Critical Introduction
by
George Moore

FYODOR DOSTOEVSKY. *Poor Folk* [21]

the 1895 trials, Edward Shelley, a young employee, testified that he had been seduced by Wilde after meeting him at the Vigo Street offices. Now sole proprietor of the Bodley Head, John Lane yielded to pressure and made a show of clearing out decadent elements by firing Beardsley from his *Yellow Book* art editorship. Beardsley, who was no champion of Wilde, was baffled and distraught, having lost both financial security and a high-profile position. Lane, however, continued to send occasional commissions his way. Even in 1896, this advertising booklet still blazoned Beardsley's connection with the "Keynotes Series" which, though aimed at sophisticated readers, was distributed widely, as the cover trumpeted, through "all Libraries"—i.e., circulating libraries with paid subscribers—along with "Booksellers" and "Railway Bookstalls."

[22]

AUBREY BEARDSLEY. *Poster for the Keynotes Series.* [London: John Lane, 1895]. Color lithograph.

Like a late-twentieth-century colorizer of old Hollywood films, Beardsley took his black-and-white design for the cover and title-page of "George Egerton's" *Keynotes* (1893) and turned it into a vibrant, eye-catching advertising poster for the "Keynotes Series" with surprising contrasts of scarlet and green against yellow. Making the female marionette's parasol a bright red, however, merely highlighted its placement and risqué status as an erect phallic object. The poster was notable, too, for shuffling the titles in the series, for which Beardsley continued to provide binding designs and title-pages, and for ignoring their chronological order of publication. By no accident, at the top of the list was the current bestseller, *The Woman Who Did* (1895), a shocking novel by Grant Allen (1848–1899) about a "New Woman" who refused to marry her lover, and who paid the price for standing by her feminist principles and raising her child as a single mother. [23]

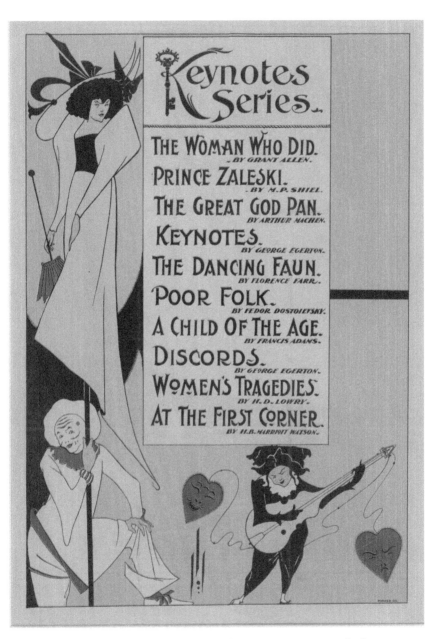

AUBREY BEARDSLEY. *Poster for the Keynotes Series* [23]

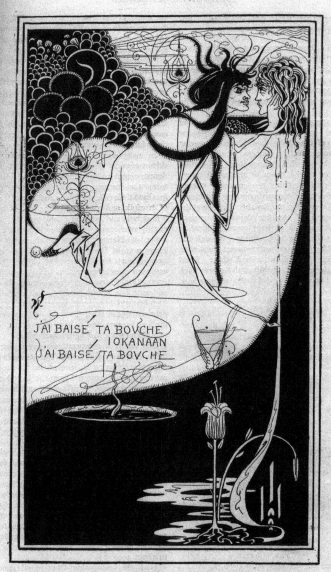

AUBREY BEARDSLEY. *J'ai baisé ta bouche Iokanaan* [24]

Wilde Times

AUBREY BEARDSLEY. *J'ai baisé ta bouche Iokanaan,* in Joseph Pennell, "A New Illustrator: Aubrey Beardsley," *The Studio: An Illustrated Magazine of Fine and Applied Art,* Volume I, Number 1, April 1893.

"Good-bye, poor genius!" wrote "W. L." [William Lawler] mournfully in *The London Year Book* of 1898, responding to Beardsley's death. There he also noted that "To Mr. Joseph Pennell is due a great part of the credit of introducing Beardsley to the world." A transplant from Philadelphia and disciple of J. M. Whistler, Pennell (1857–1926) was famed for prints and drawings in a style very different from the young Beardsley's. Nevertheless, he brought immediate, positive attention in 1893 to the unknown artist through his enthusiastic commentary in *The Studio,* a new magazine of the visual arts. Among the works reproduced in Pennell's article was Beardsley's drawing of Salome levitating after kissing the object of her desire, the severed head of John the Baptist. It was inspired by Beardsley's reading of Oscar Wilde's play, and its publication led to Beardsley receiving the commission to illustrate *Salome* for the Bodley Head. [24]

NAPOLEON SARONY. *Oscar Wilde.* Photograph, albumen cabinet card, [1882].

Oscar Wilde and Beardsley had a complicated, contentious relationship. Perhaps they had too much in common: genius and a firm belief in their own powers; ready wit and verbal panache; a taste for dressing up; the wish to create beautiful rooms and collect rare objects; love of Paris and most things French; hatred of Philistinism and the British middle classes, etc. Wilde, however, was active and reckless in pursuing young men for sex, while Beardsley seemed never to settle upon a sexual orientation, let alone sleep with anyone. Because they collaborated on the Bodley Head's edition of *Salome* (1894)—a project that found them sometimes at loggerheads—they were fused in the public imagination as decadents. When Wilde's life careened into catastrophe in 1895 with his prosecution for "gross indecency," Beardsley unjustly paid the price,

temporarily becoming *persona non grata* in publishing circles and losing work. [25]

OSCAR WILDE. *Salome: A Tragedy in One Act, Translated from the French of Oscar Wilde, Pictured by Aubrey Beardsley.* London: Elkin Mathews and John Lane, 1894. Inscribed by Aubrey Beardsley to Brandon Thomas.

So frustrating did Beardsley find the experience of collaborating with Oscar Wilde that he swore he would never repeat it and later resolved to exclude Wilde from *The Yellow Book,* after he became its art editor. But Beardsley got his own back, creating drawings for the English-language publication of *Salome* that had little to do with the action of the drama. Several were of naked, androgynous bodies; some images also incorporated caricatures of its author. Of the latter, the most obvious and wittily insulting was *The Woman in the Moon,* used as the book's frontispiece, with Wilde's face made round and lunar. This copy was presented by Beardsley to the actor Brandon Thomas (1848–1914), famed for writing the cross-dressing comedy *Charley's Aunt* (1892), with whom Beardsley, who had theatrical ambitions himself, hoped to write a play. [26]

AUBREY BEARDSLEY. *Oscar Wilde at Work.* [London: Stuart Mason, June 1914]. Photomechanical engraving on Japan vellum.

Robert, a.k.a. "Robbie," Ross (1869–1918)—Oscar Wilde's lover and later literary executor, and a close friend of Beardsley's—linked the two great dandies and decadents. Of course, dandies and decadents were not supposed to be hard workers, but Beardsley was among history's most industrious artists, producing what was calculated as over a thousand finished drawings from 1892 until shortly before his death in 1898. This caricature, which mocks Wilde's working methods, belonged to Ross. Beardsley imagines Wilde writing *Salome* in French by relying on dictionaries and textbooks, while consulting his family Bible for Salome's story. The presence, moreover, of Swinburne's poems suggests that Beardsley found Wilde's style derivative, if not imitative. Linda Zatlin's

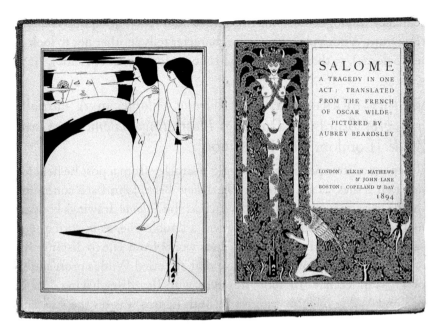

OSCAR WILDE. *Salome* [26]

AUBREY BEARDSLEY. *Oscar Wilde at Work* [27]

Beardsley catalogue raisonné notes that the French quotation changes a line from Wilde's play, where one character tells another not to look at her (Salome), so that the command is not to look at him (Wilde). [27]

AUBREY BEARDSLEY. *The Toilet of Salome*, in *A Portfolio of Aubrey Beardsley's Drawings Illustrating "Salome" by Oscar Wilde*. [London: John Lane, 1906].

Eleven years after peremptorily firing Beardsley from a post he held for only four issues, as art editor of *The Yellow Book*, John Lane continued finding ways to profit from works such as the *Salome* drawings by issuing them as a portfolio. The irony was a double one, as in spring 1895 Lane had also withdrawn all of Wilde's works from sale to distance his Bodley Head firm from the disgrace that attended Wilde's prosecution for "gross indecency." By 1906, however, with Beardsley having died in 1898 and Wilde in 1900, interest in both figures was on the rise, and *Salome* was ripe for resurrection. Separate publication of Beardsley's images worked well, as they were never illustrations per se. *The Toilet of Salome*, for instance, depicted a scene that did not exist in the play—one filled with naked androgynes and a standing fetus wrapped in a hanky, along with hands clutching at genitals, grasping phallic poles, and daintily wielding powder puffs. [28]

Notoriety

AUBREY BEARDSLEY. *Poster for the Avenue Theatre*. [London: Avenue Theatre, 1894]. Color lithograph.

The Victorian theatrical world was dominated by actor-managers who ran theatres. Most of them were men. One exception was the writer, producer, and performer Florence Farr, a "New Woman" who worked with numerous playwrights, including George Bernard Shaw (1856–1950). She employed Beardsley to design a poster to advertise a double bill she was directing on 29 March 1894 at the Avenue Theatre: *A Comedy of Sighs* by John Todhunter (1839–1916) and *The Land of Heart's Desire* by William Butler Yeats (1865–1939), both Irish authors.

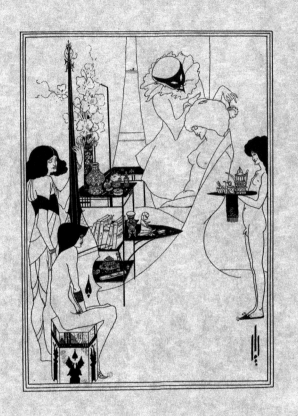

PLATE XIII

AUBREY BEARDSLEY. *The Toilet of Salome* [28]

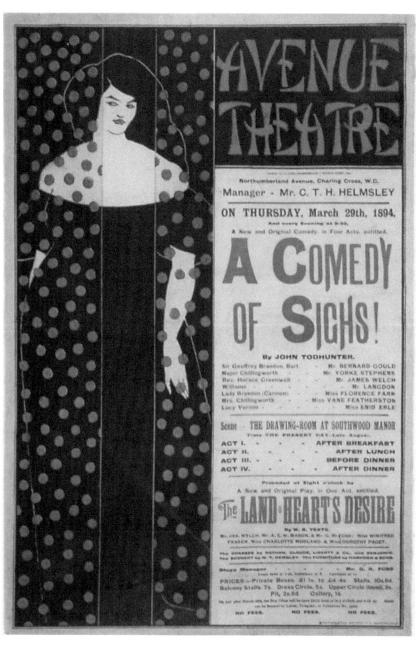

AUBREY BEARDSLEY. *Poster for the Avenue Theatre* [29]

Under the influence of French poster art and Japanese prints, Beardsley created an image that scandalized passersby in London. Its central figure was clearly no lady—uncorseted, with loose hair, and with her clothes slipping off her shoulders. It was also arrestingly modern, almost abstract, with striking use not of Beardsley's characteristic black-and-white, but color. [29]

FREDERICK HOLLYER. *William Butler Yeats*. Photograph, platinotype, [1890].

This photograph of W. B. Yeats by Frederick Hollyer (1838–1933) emphasized his beauty and artistic dress—the Aesthete's uniform of floppy tie and velvet jacket—making him the very picture of a Poet (capital "P"). Hollyer's 1893 portrait of Beardsley showed a more capricious, harder-to-read figure, staring enigmatically at the viewer with enormous eyes beneath unfashionably bowl-cut, center-parted bangs. Although Yeats and Beardsley interacted frequently, as Yeats contributed to both *The Yellow Book* and *The Savoy*, which Beardsley designed and for which he selected the artworks to be reproduced, they were never close. In the years after Beardsley's death in 1898, however, Yeats became intimately acquainted with Beardsley's sister Mabel through their mutual work in the theatre. As she succumbed to cancer in 1916, he wrote "Upon a Dying Lady," immortalizing Mabel's "lovely piteous head" and "dull red hair." [30]

AUBREY BEARDSLEY. *Poster for Children's Books*. London: T. Fisher Unwin, [1894]. Color lithograph.

Was there ever a less appropriate way to advertise publications meant for young readers? Viewers might have expected images of children listening rapt to a story, or an interpretation of the gamboling sprites from the "Brownies" series by the artist Palmer Cox (1840–1924) that featured in the accompanying list of works for sale by T. (Thomas) Fisher Unwin (1848–1935). What Beardsley offered instead in this poster was a blowsy, double-chinned woman posed against the violent magenta background of a chair—a chair that, at the top, resembled two buttocks—while sprouting from her hair was a feather curled and lumpy like a misshapen embryo. The woman was not, moreover, even engaged

in reading the book in her hand, but staring off into space with half-closed eyes, as though about to fall asleep. That Beardsley received one further commission from the same publisher in 1896 seems remarkable.

[31]

AUBREY BEARDSLEY. *Poster for Pseudonym and Autonym Libraries*. London: T. Fisher Unwin, [1894]. Color lithograph.

T. (Thomas) Fisher Unwin competed with John Lane for fiction by authors who rebelled against convention. Among the titles advertised in Beardsley's poster for the two series known as the Pseudonym and Autonym Libraries was the bestselling *Some Emotions and a Moral* (1891) by "John Oliver Hobbes" (Pearl Richards Craigie, 1867–1906), later a *Yellow Book* contributor. The poster itself was an arresting one, from the awkwardly positioned arm of its central figure, whose body seemed simultaneously to point forwards and backwards, to the inexplicable presence of a tree bound and restrained in a red frame. Beardsley's controversial images of women in advertising may have inspired "The Poster Girl," a poem by the American humorist Carolyn Wells (1862–1942), which includes the lines, "Perhaps I am absurd — perhaps/ I don't appeal to you;/ But my artistic worth depends/ Upon the point of view."

[32]

Art Editor of The Yellow Book

JOSEPH PENNELL. Autograph letter to Henry Harland, 16 April [1893].

Joseph Pennell performed two invaluable services: introducing Beardsley's work to British audiences through his 1893 article for *The Studio* and, also in 1893, introducing Beardsley himself to Henry Harland (1861–1905) with this note. (Appended to it is the signature of the writer Elizabeth Robins Pennell, Joseph's wife.) Like Pennell, Harland was a transplanted American—a novelist from Brooklyn who fell in love with bohemian Paris and modeled French attitudes (and moral latitude) when in London. This first encounter led to further

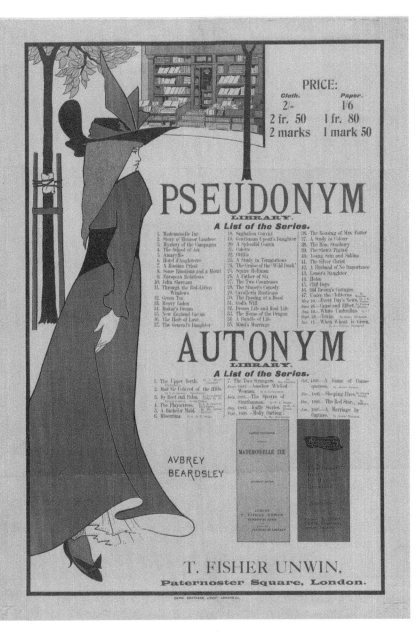

AUBREY BEARDSLEY. *Poster for Pseudonym and Autonym Libraries* [32]

Announcement

The Yellow Book

An Illustrated Quarterly

Volume I April, 1894

London : Elkin Mathews & John Lane

Price Five Shillings Net

Prospectus for The Yellow Book, Volume I, April 1894 [35]

meetings in summer 1893 at Ste. Marguerite, near Dieppe, that united Harland, Beardsley, and John Lane of the Bodley Head firm in a new venture. In the following months, they laid plans for a clothbound quarterly magazine that would eschew "illustrations," treating works of art as independent contributions, not as mere adjuncts to texts. Harland would be *The Yellow Book*'s literary editor, while Beardsley would oversee the art. [33]

AUBREY BEARDSLEY. *The Art Editor of The Yellow Book.* Pencil, charcoal, and crayon on paper, [1894].

Beardsley found his own appearance fascinating, although he considered it wanting in beauty. He represented himself on multiple occasions in a variety of styles, each one reflecting a specific aspect of his character. Usually, his preferred medium was pen and ink, but on one occasion in 1894, he used charcoal and crayon—appropriately enough, as this portrait was to be reproduced in the journal *The Sketch*. The sketch-like quality of the drawing softened his features and dress, giving him, as numerous critics have observed, a distinctly feminine look. This may have been not merely a self-revelatory, but a strategic move, considering that the image was published with the title *The Art Editor of The Yellow Book*. He created a version of himself that seemed gentle and unthreatening—just the sort of person to whom talented, but timid, young artists would have no hesitation sending their work for possible publication. [34]

Prospectus for The Yellow Book: An Illustrated Quarterly, Volume I, April 1894. London: Elkin Mathews and John Lane, 1894.

Rather than merely cooperating with the Bodley Head's promotional campaign in advance of the release of the first number of *The Yellow Book*—a campaign in which the more forceful and business-savvy John Lane played a larger role than Elkin Mathews—Beardsley helped to lead the drive. If his advertising poster for the magazine presented an image of feminine sweetness and passivity, as though reassuring the public that this new quarterly would be closer to the ideals of now-fa-

miliar aestheticism than of avant-garde decadence, his cover for the prospectus offered something quite different. Here was an edgy, dynamic scene of a woman—a "New Woman," presumably, clad all in black—out alone after dark, riffling through volumes on display in front of a bookshop improbably open at night. Beardsley gave free play to his mischievous side, too, making the ridiculous Pierrot bookseller a sour-faced caricature of Elkin Mathews. [35]

AUBREY BEARDSLEY. *Poster for The Yellow Book: Contents of Vol. 1, April 1894.* London: Elkin Mathews and John Lane, 1894. Color lithograph.

Beardsley did as much as any artist of the 1890s to blur distinctions between the fine and commercial arts. In Britain, at least, he had no rival. For many posters, he created images that were purely decorative, with little reference to the products they ostensibly were advertising. They appealed to spectators through allusion rather than through aggressive, literal marketing. Certainly, that was true of the romanticized, idyllic vision of modern femininity he used to bring attention to the first number of *The Yellow Book*. Beardsley must have had confidence in this strategy, for his own fate was bound up with the sales of the item he was promoting. Not only was he the new quarterly's art editor but, as the "Pictures" list showed, he was a major contributor, responsible for four different visual works (a number that did not include front and back covers, decorative spines, and title-pages). [36]

The Yellow Book: An Illustrated Quarterly. Volume I, April 1894. London: Elkin Mathews and John Lane, 1894. Richard Le Gallienne's copy.

Against the glare of yellow cloth, was that a bawd, laughing and masked, on the cover of the first number of the Bodley Head's avant-garde quarterly, for which Beardsley served as art editor? What sinister, sloe-eyed figure was that, with its enormous hat creating a perversely black halo behind her? Reviewing the April 1894 *Yellow Book*, an anonymous critic for *The Times* of London decried the "repulsiveness and insolence" of Beardsley's "New Art" as "a combination of English row-

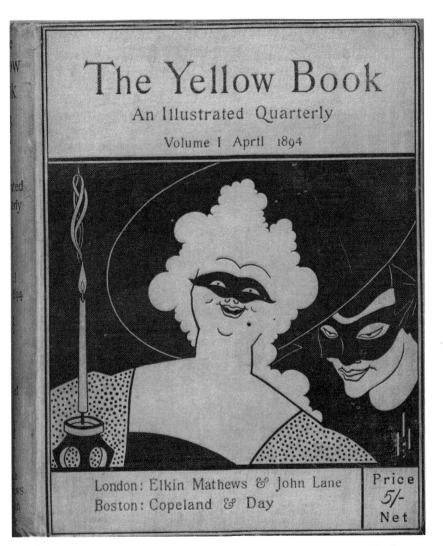

The Yellow Book: An Illustrated Quarterly. Volume I, April 1894 [37]

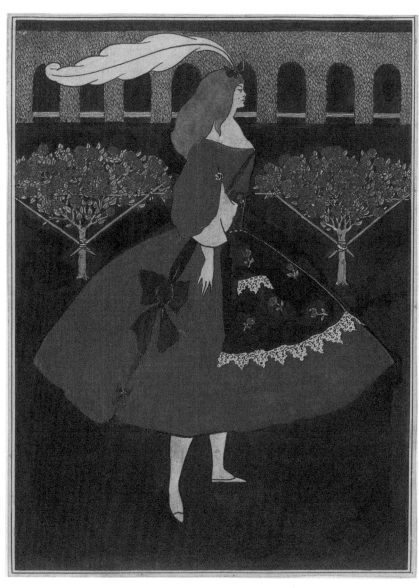

AUBREY BEARDSLEY. *The Slippers of Cinderella* [38]

dyism with French lubricity." Today, we would call his designs for the front and back covers breathtakingly modern and fearless. This copy belonged to the poet Richard Le Gallienne (1866–1947). A close associate of John Lane, Le Gallienne remained with him after the Bodley Head partnership dissolved in 1894 and even after Lane fired Beardsley from *The Yellow Book* in a panicked purge following Oscar Wilde's 1895 prosecution for "gross indecency." [37]

AUBREY BEARDSLEY. *The Slippers of Cinderella.* Ink and watercolor over pencil on paper, [1894].

Signs of an artistic foot fetish were everywhere in Beardsley's work. Some of the feet were hooflike and scarcely human; others were impossibly tiny and shod in narrow, pointed shoes. Here, the subject's right foot floating in undifferentiated black space becomes a focal point, as do her fingers, positioned in a way to suggest female genitalia. Beardsley, who seemed averse to happy endings, intended this as an illustration for a new version of the Cinderella story in which the glass slippers— ground up and fed to the unsuspecting heroine—killed her. What is happy, however, is the artist's command of color. While Beardsley was a pioneer in deploying black-and-white lines and spaces on paper, he could also use bold reds to great effect. Nonetheless, the feather sticking out of Cinderella's head, turning her into a giant ink bottle, reminds viewers that his preferred instruments were not brushes, but pens. [38]

AUBREY BEARDSLEY. *Portrait of Himself,* in *The Yellow Book: An Illustrated Quarterly. Volume III, October 1894.* London: Elkin Mathews and John Lane, 1894. Richard Le Gallienne's copy.

There were many ways to understand Beardsley's *Yellow Book* self-portrait and even more ways to interpret the accompanying text. Given the disparity between the enormous bed and Beardsley's tiny head, he appeared to be presenting himself as childlike. But the bedcurtains made that head seem to peek out from inside a woman's skirt, while the hiding of hands beneath the covers raised the possibility of some very adult activity occurring there. The words in the upper left corner, which trans-

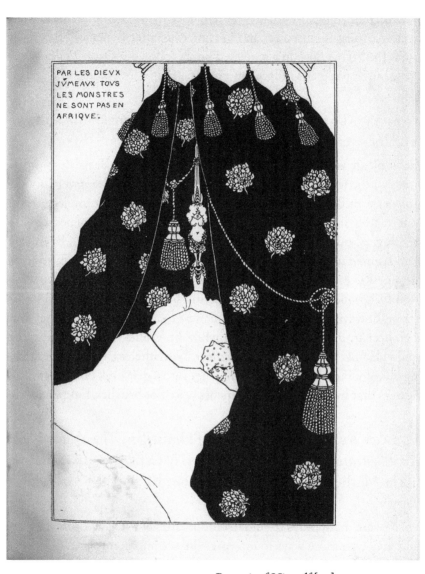

PAR LES DIEVX
JVMEAVX TOVS
LES MONSTRES
NE SONT PAS EN
AFRIQVE.

AUBREY BEARDSLEY. *Portrait of Himself* [39]

late as "By the twin gods, not all the monsters are in Africa," might have been a racist statement supporting xenophobic stereotypes; yet it also could have been a challenge to racist assumptions, suggesting that white English people like Beardsley were, on the contrary, the true "monsters." Regardless of how viewers approached this image, it offered a vision of "Himself" that was likely to raise questions and possibly provoke outrage. [39]

EDWARD TENNYSON REED. *Britannia à la Beardsley*. Ink and watercolor on paper, [1894].

As a humor magazine dedicated to conservative British values, *Punch* had long attacked Oscar Wilde, J. M. Whistler, and other representatives of the Aesthetic movement. In the 1890s, it deployed its arsenal of ridicule against the decadents. With the arrival of *The Yellow Book* (1894–1897), it had a prime target and, in the cartoonist E. T. Reed (1860–1933), a master gunner. "Britannia à la Beardsley (By Our 'Yellow' Decadent)" appeared in *Punch's Almanack*, a yearly supplement, for 1895 (actually issued in December 1894). Reed's satirical drawing offered standard elements from the iconic Britannia image—the woman warrior with spear and shield and an accompanying British lion—along with additions, such as an English bulldog. All, however, were "Beardsleyized" and rendered effete in ways that referenced *The Yellow Book* art editor's characteristic style. Most amusingly, "Mr. Punch," the magazine's famous symbol, was feminized and turned into a Beardsleyan dwarf. [40]

[ADA LEVERSON]. "From the Queer and Yellow Book I.– 1894 (By Max Mereboom)," in *Punch, or the London Charivari*, 5 February 1895.

If Beardsley had an "opposite number" among women contemporaries, it was the novelist Ada Leverson (1862–1933). Like him, she was gifted, mischievous, and incapable of passing up a chance to satirize her contemporaries, even (or especially) her dearest friends. Posterity remembers her extraordinary kindness to Oscar Wilde, whom she sheltered in her house, both when he was in the middle of the trials that led to his

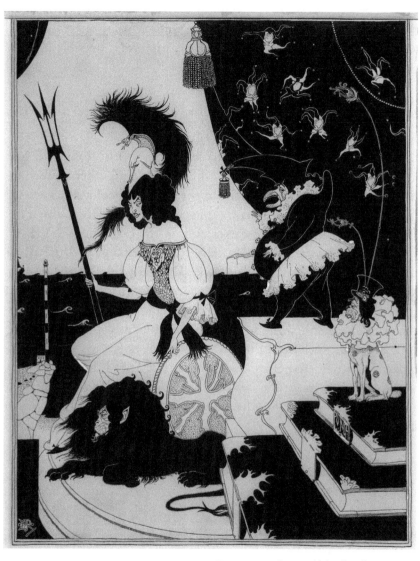

EDWARD TENNYSON REED. *Britannia à la Beardsley* [40]

FROM THE QUEER AND YELLOW BOOK.

I.—1894.

(By Max Mereboom.)

"Linger longer, LUCY,
Linger longer, LOO.
How I'd like to linger longer,
Linger longer, LOO!"—*Old Ballad.*

I SUPPOSE there is no one that has not wished, from Time to Time, that someone else had lived in another Age than his own. I myself have often felt that it would have been nice to live in 1894; to have seen the "*Living Pictures*" at the old *Empire*, to have strained my Eyes for a glimpse of *Mrs. Patrick Campbell*, broken my Cane applauding *May Yohé*, and listened to the *Blue Hungarians* while dining, on a Sunday, at that quaint old Tavern *the Savoy*. At that time the Beauties from New York had not quite lost their Vogue. CHRISTOPHER COLUMBUS, who discovered the United States, left it to the Prince of WALES to invent their inhabitants: personally, I am

Perhaps in my Study I have fallen so deeply beneath the Spell of the Age, that I have tended to underrate its unimportance. I fancy it was a Sketch of a Lady with a Mask on, playing the piano in a Cornfield, in a low dress, with two lighted Candles, and signed "*Aubrey Weirdsley*," that first impelled me to research.

But to give an accurate account of the Period would need a far less brilliant Pen than mine; and I look to JEROME K. JEROME and to Mr. CLEMENT SCOTT.

II.—TOORALOORA. A FRAGMENT.

(By Charing Cross.)

* * * * *

"My hair?" she said. "It touches the ground."
As she spoke, she seized her fringe by the roots and flung it on the floor.

"A marvellous feat for a European," I murmured with some difficulty. "Will you have another drink?"

"Yes," said *Tooraloora*; "I make it a rule always to get intoxicated in a public-house."

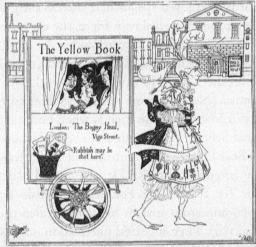

Picture by Our Own Yellow-Booky Daubaway Weirdsley, intended as a Puzzle Picture to preface of Juvenile Poems, or as nothing in particular.

more implicated with their Botany; and am, indeed, at this moment, engaged in a study of the Trees in America. Much of this remote Period must remain mobbed in the Mists of Antiquity, but we know that about then flourished the Sect that was to win for itself the Title of the "*Decadents.*" What exactly this Title signified I suppose no two entomologists will agree. But we may learn from the Caricatures of the day what the *Decadents* were in outward semblance; from the Lampoons what was their mode of life. Nightly they gathered at any of the Theatres where the plays of Mr. WILDE were being given. Nightly, the stalls were fulfilled by Row upon Row of neatly-curled Fringes surmounting Button-holes of monstrous size. The contrasts in the social Condition of the time fascinate me. I used to know a boy whose mother was actually present at the "first night" of *Charley's Aunt*, and became enamoured of *Mr. Penley*. By such links is one Age joined to another!

I should like to have been at a Private View of the "*New English Art Club.*" There was *Crotchet*, the young Author of the *Mauve Camellia*; there were *Walter Sickert*, the veteran R.A.; *George Moore*, the romanticist; *Charles Hawtrey*, the tragedian, and many another good fellow. The period of 1894 must have been delicious.

I did not offer her a chair, I flung one at her head. That impulse towards some physical demonstration, that craving for physical contact which attacks us so suddenly with its terrific impulse, and chokes and stifles us, ourselves, beneath it, blinding us to all except itself, rushed upon *Tooraloora* then: and she landed me one in the eye. Now, this was the moment I had been expecting and dreading, practically, ever since her hand had left my ear the night before—this moment when it should strike me again. I do not mean consciously, but there are a million slight, vague, physical experiences and sensations within us of which the mind remains almost unconscious; and I have no pretensions to physical courage. For a second I felt the colour rise to my face. Every expletive that should have been forgotten, I remembered. My pulses seemed beating as they do in fever, my ears seemed full of sounds, and I felt the cold touch of the policeman's grasp like ice upon my shoulder as a voice murmured, "This means forty shillings or a month.". . . When we reached the station I flung myself upon the floor, leaning my head upon my hand, the white powder upon my coat still lingered. I seemed to hear *Tooraloora* murmur, "'E don't know where 'E are."

* * * * *

[ADA LEVERSON]. "From the Queer and Yellow Book" [41]

conviction and sentence of two years at hard labor and immediately after his release from prison. But before those grim events, she engaged repeatedly in mockery of Wilde and other decadents, as in this *Punch* parody of Max Beerbohm's faux-nostalgic way of treating the present as long past. Beardsley was among her good friends, but his art for *The Yellow Book* and his ungainly, androgynous appearance were butts of vicious jokes in the accompanying visual lampoon by E. T. (Edward Tennyson) Reed. [41]

MABEL BEARDSLEY. Autograph letter to Nellie [Helen] Syrett, 17 February [1895].

Although Beardsley enjoyed spectacular success early, his sister's quest for theatrical stardom moved slowly. Here, she expresses frustration at being merely an understudy in Oscar Wilde's *An Ideal Husband*, venting her feelings to Helen, a.k.a. "Nellie," Syrett (1872–1970). She also mentions her brother's plans to write a stage work with the playwright Brandon Thomas. (Nothing came of this.) Nellie's sister, Netta Syrett (1865–1943), and Mabel became friends when both taught at the London Polytechnic School. Netta went on to be a "Keynotes Series" novelist and *Yellow Book* literary contributor, while Nellie was, like Beardsley, a precociously gifted visual artist. He encouraged Nellie, yet never recruited her for *The Yellow Book*. Following Beardsley's dismissal as art editor, however, numerous images by women filled the magazine between 1895 and 1897, when it ceased publication, suggesting his role in excluding them. Indeed, Nellie supplied the cover for the October 1896 issue. [42]

Prospectus for The Yellow Book: An Illustrated Quarterly, Volume V, April 1895. London: John Lane, 1895.

Before the April 1895 *Yellow Book* appeared, Oscar Wilde's arrest and prosecution for "gross indecency" blew the top off the Bodley Head. In America during the crisis, John Lane sent frantic communications to his staff. Threatened by homophobic authors demanding a clean sweep of the premises and its publications, he ordered Beardsley to be removed from *The Yellow Book*, because his contributions as art editor were such magnets for controversy. Henry Harland, the magazine's literary edi-

Prospectus for The Yellow Book, Volume V, April 1895 [43]

tor, was appalled, but remained loyal to Lane. Beardsley was stunned and dazed. He was part of Oscar Wilde's circle, but not of the gay male underworld. Left stranded professionally, he found an unlikely savior: Leonard Smithers (1861–1907), known for selling pornography. Beardsley soon trumpeted his new freedom, taking this image drawn for Lane and adapting it for Smithers's *Catalogue of Rare Books* (on display), with the innocent-looking faun transformed into a satyr-like Pan. [43]

Decadent Designer

MAX BEERBOHM. *Will Rothenstein Laying Down the Law.* Ink, colored chalks, and wash on paper, [ca. 1895].

Oscar Wilde would write in *The Ballad of Reading Gaol* (1898) that each man kills the thing he loves. In the case of both Max Beerbohm and Aubrey Beardsley, neither could resist the impulse to poke fun at the things—and people—they loved. Their comic art often paid homage and expressed affection in the form of ridicule. Beerbohm's caricature of his dear friend, the artist William Rothenstein, showed the latter as a dogmatic, arrogant youth who never hesitated to tell everybody how to conduct their business, whether in art, writing, or politics. Among the figures receiving his (unwanted) lectures were Oscar Wilde, the novelist George Moore, and the future King, Edward VII (1841–1910), along with Beardsley. Identified as "AUBREY," he is here a wispy, hawk-nosed outline in profile with a tiny top hat balanced on his head, perhaps echoing one of Beardsley's own Bon-Mots grotesques. [44]

JOHN DAVIDSON. *A Full and True Account of the Wonderful Mission of Earl Lavender. . . with a Frontispiece by Aubrey Beardsley.* London: Ward and Downey, 1895. Inscribed by John Davidson to Aubrey Beardsley.

Ordinarily, Beardsley was the one who added sexual innuendo and salacious imagery not found in the original text. When asked to provide a frontispiece for the picaresque fantasy known as *Earl Lavender*, by John

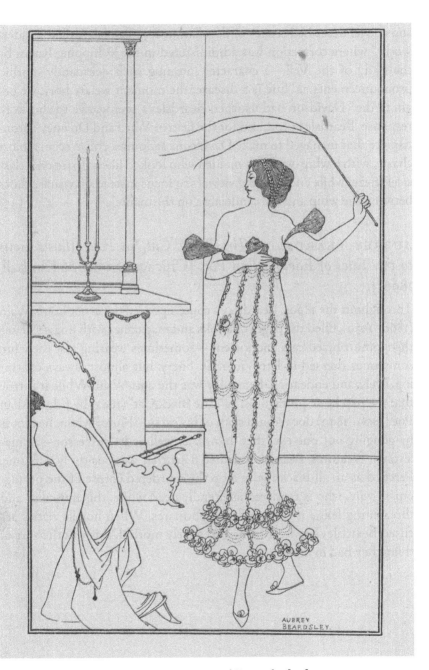

JOHN DAVIDSON. *Earl Lavender* [45]

Davidson (1857–1909), however, he had the opposite problem. Davidson's novel described scenes of flagellation set in a place called "Underworld," where correction was administered in the Whipping Room by the Lady of the Veil—a character intoning such decadently morbid pronouncements as "Life is a disease: the moment we are born we begin to die." Davidson had usurped Beardsley's prerogative to shock. In response, Beardsley produced for the firm of Ward and Downey a frontispiece that managed to make Davidson's sadomasochism seem almost chaste, with a whip-wielding maiden who looked like a figure on a classical frieze, while encouraging viewers to focus instead on visual echoes between the whip and the candelabra on the mantel. [45]

AUBREY BEARDSLEY. *The Black Cat*, in *Four Illustrations to the Tales of Edgar Allan Poe.* [Chicago: Stone & Kimball, 1896?].

Throughout the 1890s, Beardsley's contemporary, the artist Louis Wain (1860–1939), filled the pages of books and magazines with images of anthropomorphized cats and kittens—sometimes wearing just their fur, sometimes dressed in late-Victorian finery, but almost always charming, lively, and endearing. Beardsley was the anti-Wain. While it is true that the psychotic protagonist of "The Black Cat" (1843) by Edgar Allan Poe (1809–1849) does regard both of his cats—"Pluto," whom he blinds by gouging out one eye, then hangs, as well as its successor—as malevolent creatures, Beardsley created a cat that was positively demonic. Perched as an all-black figure atop the murdered corpse of the protagonist's wife, who is rendered as literally dead white, this muscular and threatening feline is the stuff of nightmares. When hostile critics accused Beardsley's style of being excessively morbid, this was the sort of thing they had in mind. [46]

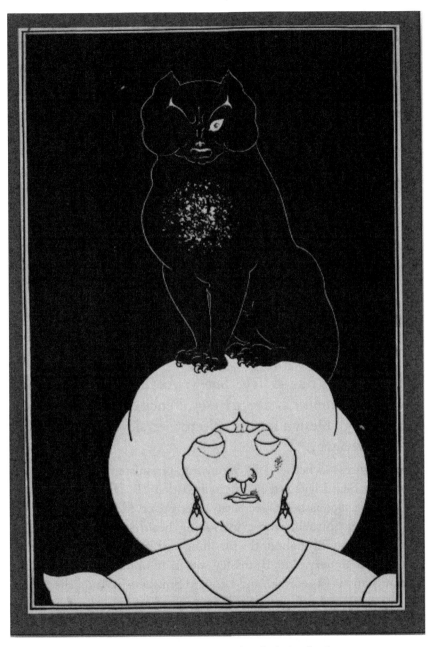

AUBREY BEARDSLEY. *The Black Cat* [46]

The Savoy and Smithers

LEONARD SMITHERS. *Catalogue of Rare Books Offered for Sale by Leonard Smithers, No. 3–September 1895.* London: Leonard Smithers, 1895.

Beardsley's delight in the idea of pansexuality was literal: he delighted in drawing a sexual Pan. Which book sold by Leonard Smithers was this grinning Greek nature god so improbably reading aloud, in a sylvan setting, to a Victorian woman? There were many choices: perhaps one of the respectable antiquarian volumes listed in this catalogue; a work of poetry or prose, written by a member of the contemporary decadent movement and published by Smithers; or an example of the pornography in which Smithers had been doing a clandestine trade for years. The same daring spirit that led him to traffic in the forbidden also encouraged him to recruit the poet Arthur Symons (1865–1945) as editor of a new magazine, *The Savoy,* and to put Beardsley in charge of its art contents, while also employing him to produce book designs and illustrations for other publications. [47]

AUBREY BEARDSLEY. *The Savoy: An Illustrated Quarterly, Prospectus, Number I. Dec 1st 1895.* Pencil, brush, and ink on paper, [1895]. Design for the "Pierrot" version of the prospectus for *The Savoy.*

Pierrot figures—whether jolly, mournful, or sinister—were recurring features of Beardsley's art. In a drawing titled *The Death of Pierrot* for the October 1896 issue of *The Savoy,* Pierrot served as a grim stand-in for Beardsley himself, whose worsening health made him contemplate mortality. Throughout the planning of *The Savoy,* however, which launched in January 1896, Beardsley was in an optimistic mood, as he, Arthur Symons (its editor), and Leonard Smithers (its publisher) plotted the creation of a magazine of literature and art to rival and outshine *The Yellow Book.* His Pierrot for the prospectus was thus a merry fellow, clutching a huge pen and, in a hall-of-mirrors effect, the very brochure that he ornamented. Legend has it that Smithers found the image too frivolous. For a clown, therefore, Beardsley substituted John Bull, per-

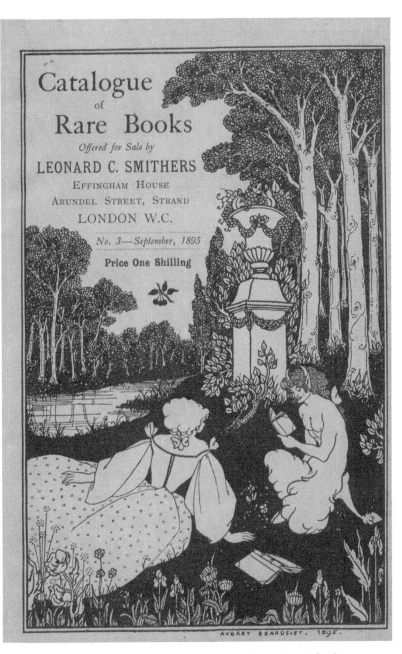

LEONARD SMITHERS. *Catalogue of Rare Books* [47]

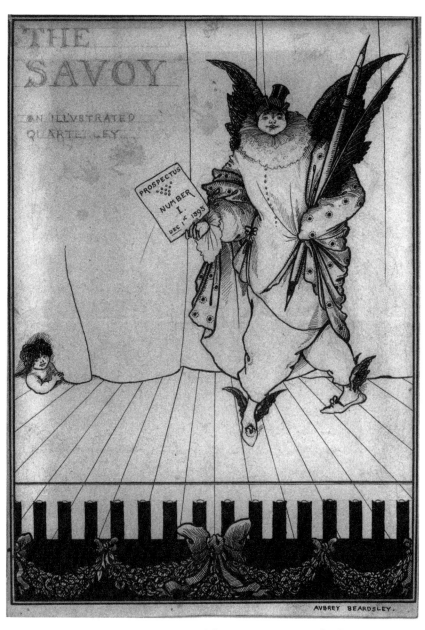

AUBREY BEARDSLEY. *The Savoy: Prospectus* [48]

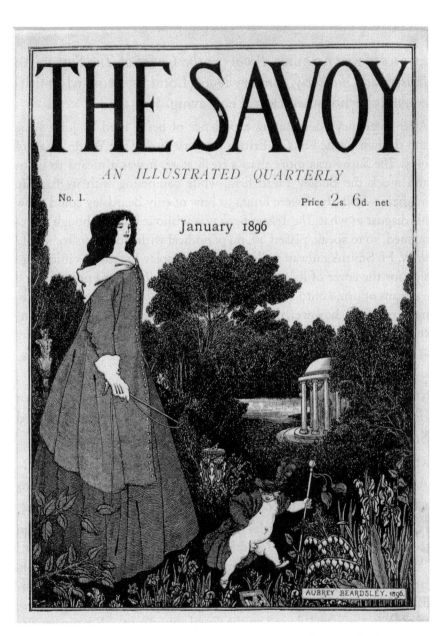

AUBREY BEARDSLEY. *Proof for the Cover of The Savoy* [49]

sonification of the English public, but snuck in a minute bulge in this character's trousers. [48]

AUBREY BEARDSLEY. *Proof for the Cover of The Savoy: An Illustrated Quarterly, January 1896.* [London: Leonard Smithers, 1895]. Photomechanical engraving.

After Beardsley's devastating experience of being fired by John Lane and thrown to the lions of British prudery during the Wilde Trials of 1895, *The Savoy* was more than a fresh start; it was a means to taunt and mock the Bodley Head firm, while competing with its flagship magazine. Still, there were limits to how openly Beardsley could show his disgust at what *The Yellow Book* was without him. Although he remained, so to speak, pissed off, no periodical with ambitions to be sold in W. H. Smith's railway stalls could ever display Beardsley's initial design for the cover of its first number, with a half-dressed putto aiming a stream of urine onto a copy of *The Yellow Book*. With that visual element removed, however, the rest of *The Savoy's* cover was left intact, including the ambiguous presence of a whip in the woman's hand, hinting at sadomasochistic possibilities. [49]

AUBREY BEARDSLEY. "Under the Hill," in *The Savoy: An Illustrated Quarterly. No. 1, January 1896.* London: Leonard Smithers, 1896.

AUBREY BEARDSLEY. *The Story of Venus and Tannhäuser... A Romantic Novel; Now First Printed from the Original Manuscript.* London: For Private Circulation, 1907.

From earliest youth, Beardsley yearned to be a writer. In 1894, when tackling the Venus and Tannhäuser legend that inspired Richard Wagner's opera, he planned a long narrative blending myth, religion, fantasy, wit, and satire with lots of sex. Two years later, he started publishing the results in installments in *The Savoy*, accompanied by illustrations in a new style based on the visual abundance of Rococo art, using techniques such as cross-hatching that he previously avoided. At his death, the novel remained unfinished. When, however, Leonard Smithers issued a privately printed version in 1907, it was clear how heavily

UNDER THE HILL

CHAPTER I

THE Abbé Fanfreluche, having lighted off his horse, stood doubtfully for a moment beneath the ombre gateway of the mysterious Hill, troubled with an exquisite fear lest a day's travel should have too cruelly undone the laboured niceness of his dress. His head, thin and gracious as La Marquise de Deffand's in the drawing by Carmontelle, played nervously about the gold hair that fell upon his shoulders like a finely-curled periuke, and from point to point of a precise toilet the fingers wandered, quelling the little mutinies of cravat and ruffle.

It was taper-time, when the tired earth puts on its cloak of mists and shadows, when the enchanted woods are stirred with light footfalls and slender voices of the fairies, when all the air is full of delicate influences, and even the beaux, seated at their dressing-tables, dream a little.

A delicious moment, thought Fanfreluche, to slip into exile.

The place where he stood waved drowsily with strange flowers, heavy with perfume, dripping with odours. Gloomy and nameless weeds not to be found in Mentzelius. Huge moths, so richly winged they must have banqueted upon tapestries and royal stuffs, slept on the pillars that flanked either side of the gateway, and the eyes of all the moths remained open and were burning and bursting with a mesh of veins. The pillars were fashioned in some pale stone and rose up like hymns in the praise of pleasure, for from cap to base, each one was carved with loving sculptures, shewing such a cunning invention and such a curious knowledge, that Fanfreluche lingered not a little in reviewing them. They surpassed all that Japan has ever pictured from her maisons vertes, all that was ever painted on the cool bath-rooms of Cardinal La Motte, and even outdid the astonishing illustrations to Jones's "Nursery Numbers."

AUBREY BEARDSLEY. "Under the Hill," in *The Savoy* [50]

Catullus . Carm. CI.

By ways remote & distant waters sped,
Brother to thy sad grave-side am I come,
That I may give the last gifts to the dead,
And vainly parley with thine ashes dumb:
Since she who now bestows & now denies
Hath ta'en thee, hapless brother, from mine eyes.

But lo! these gifts, the heirlooms of past years
Are made sad things to grace thy coffin shell,
Take them, all drenchèd with a brother's tears,
And brother, for all time, hail & farewell!

AUBREY BEARDSLEY. *Catullus Carmen CI* [53]

expurgated what appeared in *The Savoy* had been. Fetishism, group sex, oral sex, even child rape—all were there, served up with a sly smile. *My Little Pony* fans be warned: on display is the description of Venus bringing her unicorn to orgasm, then enjoying his semen as her breakfast treat. [50 & 51]

AUBREY BEARDSLEY. Autograph letter to Ada Leverson, [17 February 1896].

Ada Leverson and Beardsley took mutual pleasure in their friendship, exercising their gifts for wit whenever they were together and in exchanges of letters. In February 1896, Beardsley was deeply engaged in his new project, overseeing the art contents for Leonard Smithers's *The Savoy*, while working alongside its editor, the poet Arthur Symons. He thought well of the intellectual powers of Symons, who was the first important British critic to theorize about and defend decadence as a serious artistic movement. This did not stop Beardsley, when writing to Leverson, from referring to him as "Simple Symons" (playing on the "Simple Simon" nursery rhyme). In the same letter, Beardsley referred to an "unpleasant experience with a Planchette," meaning a Ouija Board used in séances. But most eye-catching was his gender-bending joke about how this encounter with the occult had left him "quite a wreck" and thus "no longer the same woman." [52]

AUBREY BEARDSLEY. *Catullus Carmen CI.* Autograph manuscript, [1896].

In his "Editorial Note" for *The Savoy* of November 1896, Arthur Symons ruefully announced that "with the next number" the magazine would "come to an end"—a short lifespan for a publishing venture that only had begun in January of that year. Fittingly, the same issue contained Beardsley's drawing *Ave Atque Vale*, depicting a half-undressed classical figure with furrowed brow and raised arm, bidding someone out of sight good-bye. On the opposite page was printed Beardsley's own translation from Latin of Catullus's "Carmen CI," which concluded with the words, "And, brother, for all time, hail and farewell!" Displayed here is that translation in Beardsley's hand. Less than two years later, of course, the world would be forced to say its final, bitter, and much-too-

early farewell to Beardsley himself, when he succumbed to tuberculosis in Menton, France. [53]

ERNEST DOWSON. *Verses*. London: Leonard Smithers, 1896. Large paper copy, inscribed by Ernest Dowson to Leonard Smithers.

Legend has it that, when asked to explain his front cover design for *Verses* by Ernest Dowson (1867–1900), which resembled a large letter "Y," Beardsley replied that he wondered why the book had been published. The answer was that Dowson's poetry appealed to Leonard Smithers, who began his career by trafficking in pornography and retained an interest—personal, as well as financial—in perverse sexualities, even after becoming known as "Publisher to the Decadents." A number of Dowson's lyrics celebrated child-love and grew out of his actual obsession with an eleven-year-old girl. Although Beardsley delighted in offending, he wisely went with a cover image that was abstract, not representing a man pursuing an underage beauty. Similar "Y" shapes can be found throughout Beardsley's work, suggesting that he may have wished to make them a kind of signature, much as Whistler had done with the outline of a butterfly. [54]

ALEXANDER POPE. *The Rape of the Lock: An Heroi-comical Poem in Five Cantos, Written by Alexander Pope, Embroidered with Eleven Drawings by Aubrey Beardsley*. London: Leonard Smithers, 1896. Inscribed by Aubrey Beardsley to Alfred Gurney.

ALEXANDER POPE. *The Rape of the Lock: An Heroi-comical Poem in Five Cantos, Written by Alexander Pope, Embroidered with Eleven Drawings by Aubrey Beardsley*. London: Leonard Smithers, 1897. Bijou edition.

His reputation was built on flat planes, stark black-and-white contrasts, and spareness associated with Japanese aesthetics, but Beardsley had command of many styles. He was equally attracted to overabundant decoration, especially in eighteenth-century engravings. Leonard

THE RAPE OF THE LOCK

CANTO I

WHAT dire Offence from am'rous Causes springs,
 What mighty Contests rise from trivial Things,
I sing—This verse to CARYL, Muse! is due;
This, ev'n *Belinda* may vouchsafe to view:

B

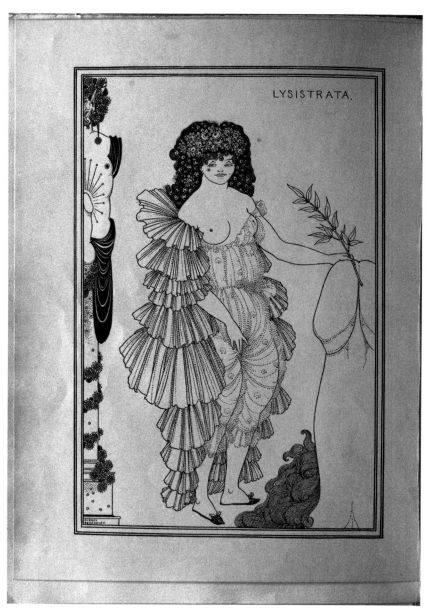

ARISTOPHANES. *The Lysistrata of Aristophanes* [58]

Smithers produced *The Rape of the Lock* by Alexander Pope (1688–1744) in different formats—one a cheaper, smaller "Bijou" edition—with Beardsley's images. Beardsley did not precisely illustrate the text; instead, he made it a point of departure. Describing his method, he employed the word "embroidered," which both indicated his practice of adding what was not there originally and positioned his art in solidarity with the feminine sphere of material handicrafts. His image of Belinda with her hand reaching suggestively under the covers was an example of something definitely not present in Pope's poem. The larger copy here was given by Beardsley to Alfred Gurney (1843–1898), the Beardsley family's beloved priest. [55 & 56]

AUBREY BEARDSLEY. *Autumn.* Ink on paper, [1896].

However unlikely the subject, Beardsley always found ways to introduce epicene pseudo-classical nudes and objects practically exploding with erotic potential—in this case, decorative naked bodies ending in goatish loins and hooves, along with clusters of grapes meeting the lips of a woman in a sensual kiss and flowers standing at erect attention. Linda Zatlin's Beardsley catalogue raisonné identifies Autumn as intended for a calendar to be issued by William Heinemann (1863–1920). His firm was sometimes in competition with the Bodley Head for signing up new authors, especially those whose work embraced international influences. Evidently, the project was discarded when the publisher, who was aiming for a wide market, saw this overtly risqué image. Given Beardsley's long record by 1896 of pushing the sexual envelope, viewers today can only wonder why Heinemann was surprised. [57]

ARISTOPHANES. *The Lysistrata of Aristophanes: Now First Wholly Translated into English and Illustrated with Eight Full-page Drawings by Aubrey Beardsley.* London: [Leonard Smithers], 1896. With autograph letter from Aubrey Beardsley to Leonard Smithers, 19 December 1895.

He had scant interest in politics or matters of war and peace, but Beardsley found *Lysistrata* by the classical Greek playwright Aristophanes irresistible for other reasons. This comedy about wives

on a sex strike to force their husbands to end the Peloponnesian War offered him boundless opportunities to do what he loved most: draw genitalia, including engorged penises larger than the bodies of the men to whom they belonged. While doing so, he demonstrated that in his hands (so to speak) sexual organs could have as much individual character as faces. *Lysistrata* was also a feminist play, about women's power, and Beardsley's frontispiece showed a formidable woman whose fingers—as in Beardsley's earlier *Cinderella* (1894)—were used to suggest her labia majora. This copy of *Lysistrata* is accompanied by a note from Beardsley to its publisher, Leonard Smithers. [58]

AUBREY BEARDSLEY. *The Artist's Bookplate,* in *A Book of Fifty Drawings, with an Iconography by Aymer Vallance.* London: Leonard Smithers, 1897. Inscribed by Aubrey Beardsley to Gabrielle Réjane.

Bookplates, along with posters, became newly important art forms in the late-Victorian period. In 1891, the founding of the Ex Libris Society helped to make bookplates not merely collectible, but respectable. As always, Beardsley dedicated himself to upending, so to speak, all notions of respectability. Only he would have designed something that placed books in the background and buttocks in the foreground, right in the viewer's face, or depicted a naked woman reaching not for clothes, but for a bound volume. He used this image to create a bookplate for Herbert Charles Pollitt (1871–1942), a.k.a. Jerome Pollitt, who was famed for cross-dressed stage performances at Cambridge University and for a brief romantic liaison with the notorious practitioner of Dark Magic, the writer Aleister Crowley (1875–1947). Beardsley inscribed this copy of *A Book of Fifty Drawings* to the French actress, Gabrielle Réju (1856–1920), known as "Réjane." [59]

AUBREY BEARDSLEY. *The Lady with the Monkey,* in *Six Drawings Illustrating Théophile Gautier's Romance Mademoiselle de Maupin.* London: Leonard Smithers, 1898.

Among American writers, Edgar Allan Poe was the one with the most profound influence on Beardsley. No single French author had equal

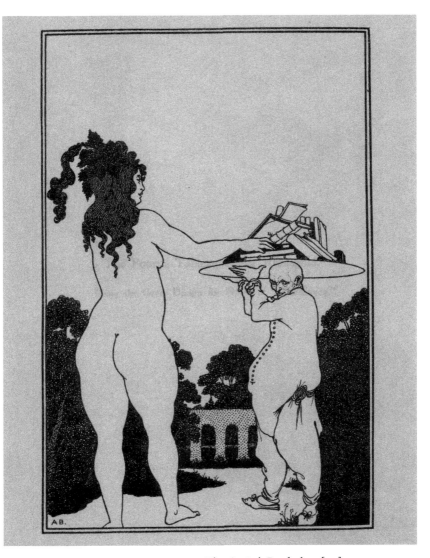

AUBREY BEARDSLEY. *The Artist's Bookplate* [59]

AUBREY BEARDSLEY. *The Lady with the Monkey* [60]

impact; Beardsley was a devotee of French literature in general. He enjoyed an excellent command of the language and always read works in the original French. His last year of life was spent in France, where one of his final projects was to illustrate *Mademoiselle de Maupin* by Théophile Gautier (1811–1872). The novel held obvious appeal with plot elements of cross-dressing and same-sex desire, which always ignited his imagination, as did the opportunity to depict taboo body parts. Curiously, this illustration for Leonard Smithers's posthumously released edition showed not only a bare-breasted woman, but an elaborately attired monkey with long, flat feet much like those in E. T. Reed's 5 February 1895 *Punch* caricature of Beardsley. Was this little figure with its wizened face a comic self-portrait? [60]

BEN JONSON. *Ben Jonson, His Volpone: or, The Foxe: A New Edition, with… a Frontispiece, Five Initial Letters and a Cover Design, Illustrative and Decorative, by Aubrey Beardsley, Together with an Eulogy of the Artist by Robert Ross.* London: Leonard Smithers and Co., 1898. Inscribed by Robert Ross to Max Beerbohm.

BEN JONSON. *Ben Jonson, His Volpone: or, The Foxe: A New Edition, with… a Frontispiece, Five Initial Letters and a Cover Design, Illustrative and Decorative, by Aubrey Beardsley, Together with an Eulogy of the Artist by Robert Ross.* London: Leonard Smithers and Co., 1898. Special issue bound in vellum. Inscribed by Leonard Smithers to his wife, Alice Smithers.

Oddly, Beardsley never illustrated Shakespeare's plays—*A Midsummer Night's Dream* would have seemed an obvious choice, given Beardsley's Puckish temperament—but did suggest to Leonard Smithers an edition of *Volpone* (1606) by Ben Jonson (1572–1637). Embarking on it, Beardsley explored a new style that substituted shading and greater realism for his earlier spare, Japanese-influenced aesthetic. As his health deteriorated, however, he was forced to abandon the project after completing a front cover design, a drawing of Volpone worshiping his treasures, and several extraordinary decorative initial letters. *Volpone* was

BEN JONSON. *Ben Jonson, His Volpone* [61]

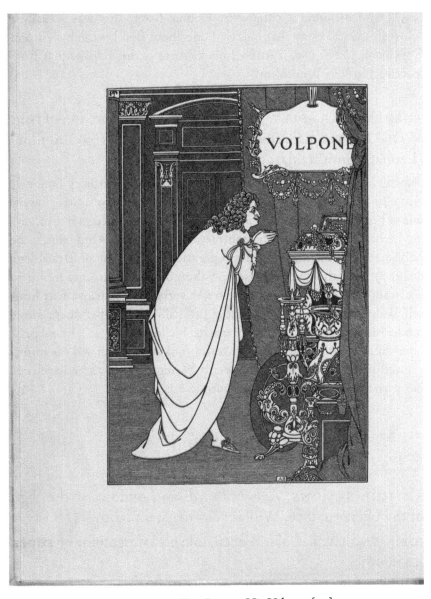

BEN JONSON. *Ben Jonson, His Volpone* [62]

published posthumously—this copy, one of a hundred on vellum, was presented by Leonard Smithers to his wife, Alice Edith Oldham (1861–1915)—and included a "eulogy" by Robbie Ross. This was actually a full-scale critical essay that followed one about Ben Jonson by Vincent O'Sullivan (1868–1940). Also displayed here is the *Volpone* that Ross inscribed to Max Beerbohm. [61 & 62]

AUBREY BEARDSLEY. *Juvenal Scourging Woman*, in *An Issue of Five Drawings Illustrative of Juvenal and Lucian*. London: [Leonard Smithers], 1906.

Shortly before dying in Menton, France, in 1898, Beardsley famously wrote to Smithers, begging him by "all that was holy" to "destroy" every one of his "obscene drawings," and Smithers famously lied in return, saying he had complied. On the contrary, for several years afterwards the publisher ran a lucrative business operation capitalizing on Beardsley's death. Among the items released posthumously were images meant to illustrate works of classical literature. A verbal and visual satirist himself, Beardsley had long appreciated Juvenal's take-no-prisoners comic mode. Here, though, Beardsley depicted his forerunner as a literal prisoner-taker, holding captive a powerful-looking woman who is unimpressed by the exertions of this penis-baring Juvenal, as he flagellates her with a thin whip, rather than with words alone. [63]

Last Stand

ARTHUR SYMONS, *Aubrey Beardsley*. London: At the Sign of the Unicorn, 1898. William Rothenstein's copy.

JOHN WALLACE. *Isolde*. Pencil, ink, and watercolor on paper, [ca. 1896].

The legend of Tristan and Isolde's ill-fated passion had Celtic origins, but Beardsley was more interested in the German opera by Richard Wagner (1813–1883). Characters whose desires compelled them to break their society's rules held great appeal for him, as did anything ending in an orgasmic musical climax. For *The Studio* magazine in 1895,

JUVENAL SCOURGING WOMAN

AUBREY BEARDSLEY. *Juvenal Scourging Woman* [63]

AUBREY BEARDSLEY. *Isolde* [64]

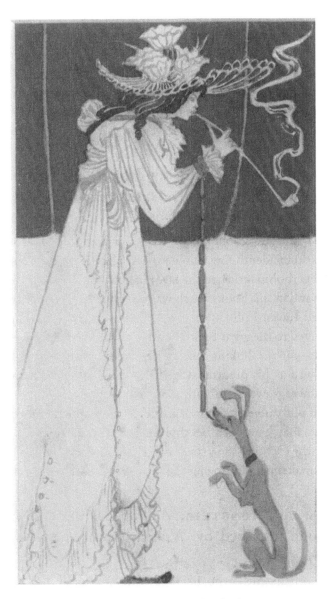

JOHN WALLACE. *Isolde* [65]

Beardsley depicted Isolde about to drink the love potion that set the events in motion. That image was reproduced in Arthur Symons's posthumous volume in tribute to Beardsley, and the copy on display belonged to fellow artist, William Rothenstein. Tribute of a very different sort, however, had been paid earlier in the form of visual lampoon by John Wallace (1841–1903), a.k.a. "George Pipeshanks," best known for his advertising work for the Cope Brothers' tobacco company. His version of Beardsley's *Isolde* had her smoking, while a dog licked German sausages suspended from her wrist. [64 & 65]

MAX BEERBOHM. *Mr. Aubrey Beardsley*, in *Caricatures of Twenty-Five Gentlemen, with an Introduction by L. Raven-Hill.* London: Leonard Smithers, 1896. Siegfried Sassoon's copy.

In an 1894 *Bon-Mots* volume, Beardsley caricatured Max Beerbohm, though without identifying him as the subject of a grotesquely comic drawing. Beerbohm returned the favor in both the April 1896 number of *The Savoy* and in this book, which was accompanied by an Introduction by Leonard Raven-Hill (1867–1942), a fellow artist. (The copy shown here belonged to the great First World War soldier-poet, Siegfried Sassoon [1886–1967].) Poking fun at Beardsley meant emphasizing his youth, as well as his preoccupation with things French, by portraying him as an overgrown child with a pull-toy—a poodle doll on a string. The row of puffy objects along Beardsley's name, which resembled flowers or trees, may have been Beerbohm's naughty allusion to Beardsley's design for the October 1894 cover of *The Yellow Book*, with a prostitute doing her makeup and using just such a powder puff on a stick. [66]

WILLIAM ROTHENSTEIN. *Aubrey Beardsley*. Lithograph, 1897. Proof, inscribed by William Rothenstein to Aubrey Beardsley.

William Rothenstein—who, like Beardsley, was enthralled by contemporary French art and by Japanese prints, erotic and otherwise—was close friends with Max Beerbohm and introduced the two comic artist-writers to one another in 1894. It was not, however, the laughing, but the serious side of Beardsley that Rothenstein captured in 1897,

MAX BEERBOHM. *Mr. Aubrey Beardsley* [66]

when his subject was increasingly debilitated by tuberculosis and already looking death in the face. This pensive portrait later appeared in Rothenstein's *Liber Juniorium* portfolio (1899). Although Rothenstein began life as a Jewish outsider to English society, he was knighted in 1931. Beerbohm was knighted, too, in 1939. It is interesting to speculate whether, had he lived longer, the world would have seen the creation of Sir Aubrey Beardsley. [67]

ABEL. *Aubrey Beardsley.* Photograph, silver gelatin cabinet card, [November 1897]. Inscribed by Aubrey Beardsley to Herbert Pollitt.

In his final years, Beardsley came within the orbit of Marc-André Raffalovich (1864–1934)— French-born author of *Uranisme et unisexualité* (1896), a study of same-sex love—who lived in London and became the partner of the poet John Gray (1866–1934), allegedly the inspiration for Oscar Wilde's fictional "Dorian Gray." Both Gray and the Jewish Raffalovich converted to Roman Catholicism in the mid-1890s. Beardsley felt moved to do the same, influenced not only by their example, but by his sister, Mabel. It was a spiritually driven decision, not a response to Raffalovich acting as his chief financial support when he grew too ill to undertake artistic commissions. A little-known photographer, M. Abel, made this image of Beardsley seated near a prominently placed crucifix in his hotel room in Menton, France, where he went for his health and was nursed by his mother. Beardsley sent it to his friend, Herbert Pollitt. [68]

A Solemn Mass of Requiem for the Repose of the Soul of Aubrey Beardsley Will Take Place at the Church of the Immaculate Conception, Farm Street, Berkeley Square, on May 12th, at 10.30. [London, 1898].

With his mother and sister at his bedside, Beardsley died of tuberculosis on 16 March 1898 in Menton. Following a Catholic funeral, he was buried there. Two months later, a requiem mass was held in London— one way in which friends and admirers dealt with their shock and grief. At age fourteen Beardsley had, as his biographer Matthew Sturgis re-

ABEL. *Aubrey Beardsley* [68]

A Solemn Mass of Requiem for the Repose of the Soul of Aubrey Beardsley [69]

cords, inscribed a book "to A. V. Beardsley from his loving self." By the time of his too-early death, many other people dearly loved him and his art. That art gave his life purpose; he struggled to create even in his final days. In her 1921 manuscript notes (on view in this exhibition), his mother reported discovering, after his death, the pen he favored "sticking into the floor" where "he must have thrown it away [on] finding he could not draw" any longer. Erect and defiant, it was Beardsley's last stand. [69]

Bibliography

Beardsley, Aubrey. *Bons Mots & Grotesques*. Edited by Matthew Sturgis. London: Pallas Athene, 2020.

_____. *The Letters of Aubrey Beardsley*. Edited by Henry Maas, J. L. Duncan, and W. G. Good. Rutherford, NJ: Fairleigh Dickinson University Press, 1970.

Calloway, Stephen. *Aubrey Beardsley*. London: V&A Publications, 1998.

Calloway, Stephen and Caroline Corbeau-Parsons, eds. *Aubrey Beardsley*. London: Tate Britain, 2020.

Frankel, Nicholas. *Masking the Text: Essays on Literature & Mediation in the 1890s*. High Wycombe, UK: Rivendale, 2009.

Lasner, Mark Samuels. *The Bookplates of Aubrey Beardsley*. High Wycombe, UK: Rivendale, 2008.

_____. *A Selective Checklist of the Published Work of Aubrey Beardsley*. Boston: Thomas G. Boss, 1995.

Marsh, Jan. *Aubrey Beardsley: Decadence & Desire*. London: Thames & Hudson, 2020.

Nelson, James G. *Publisher to the Decadents: Leonard Smithers in the Careers of Beardsley, Wilde, Dowson*. University Park, PA: Pennsylvania State University Press, 2000.

Reade, Brian. *Aubrey Beardsley*. 1967; rev. ed. Woodbridge, UK: Antique Collectors' Club, 1987.

Stetz, Margaret D. and Mark Samuels Lasner. *England in the 1890s: Literary Publishing at the Bodley Head*. Washington, DC: Georgetown University Press, 1990.

_____. *The Yellow Book: A Centenary Exhibition*. Cambridge, MA: Houghton Library, Harvard University, 1994.

Sturgis, Matthew. *Aubrey Beardsley: A Biography*. London: HarperCollins, 1998.

Zatlin, Linda Gertner. *Aubrey Beardsley: A Catalogue Raisonné*. New Haven and London: Yale University Press, 2016.

_____. *Aubrey Beardsley and Victorian Sexual Politics*. Oxford and New York: Oxford University Press, 1990.

_____. *Beardsley, Japonisme, and the Perversion of the Victorian Ideal*. Cambridge: Cambridge University Press, 1997.

9781605831114